In Praise of Hands

Woodcuts by Naoko Matsubara
with poems by Penny Boxall

Edited by Clare Pollard

ASHMOLEAN
MUSEUM
OXFORD

In Praise

Woodcuts by Naoko Matsubara

with poems by Penny Boxall

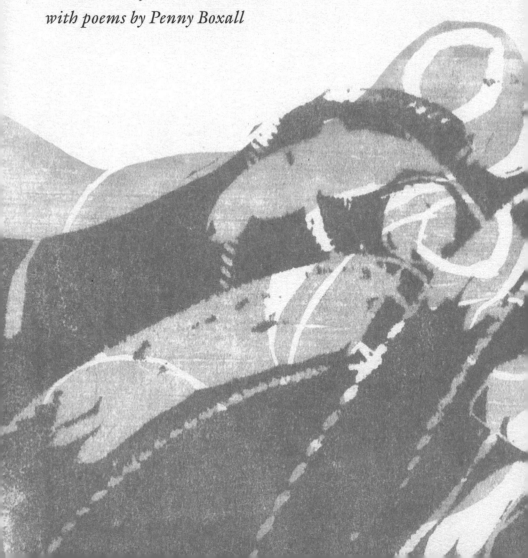

f Hands

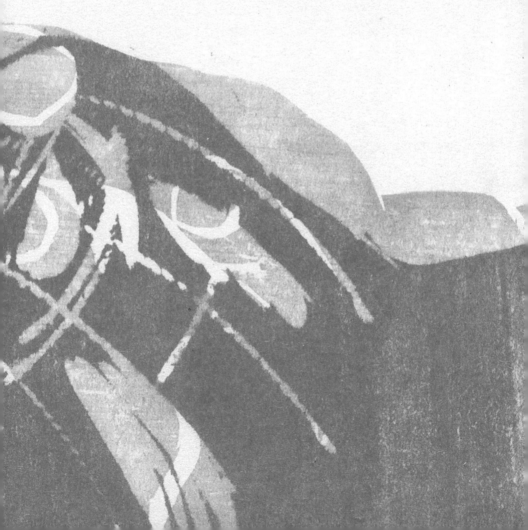

Naoko Matsubara

I have been creating woodcuts on the theme of 'Hands' for very many years.

The idea of hand movements as a focus in my work goes back to 1973. My son Yoshiki was born that year and I watched my tiny beautiful infant child develop day in and day out.

His tiny hands, at first clenching tightly, started to open up, and it startled me to see the very beginnings of human communication fluently expressed in so much variety. I was astonished at the extraordinary ability of those tiniest and softest of hands to pull, push, twist, scratch, hit, pat, squeeze, squash, hold, pinch, shake, point, poke, search, clap, rub and so forth. This discovery of the cleverness of human hands through my baby was the genesis of a series of woodcuts that I called 'In Praise of Hands'.

While I have, over time, been approached by several publishers to produce this 'Hands' series as a book, the perfect moment arrived through connection with Dr. Clare Pollard, Curator of Japanese Art at the Ashmolean Museum. I am delighted that 'In Praise of Hands' will be published by such a venerable institution. I am also honoured that Clare was able to engage as gifted a poet as Penny Boxall to create

a poem for each woodcut. Penny has approached the series with a depth of inquiry, understanding, and talent that has me marvel at the synergy between inspiration and response. Penny's poems are closely evocative of the woodcut images that were their genesis, but they are also literary gems in their own right. I am more than thrilled to see this beautiful collaboration come to fruition here, in this book, *In Praise of Hands*.

Penny Boxall

I remember standing in the Ashmolean in front of a glorious print of a kimono – a portrait in bold and nuanced blocks of colour, the grain of the wood recurring in it like fingerprints. Naoko Matsubara's image was a playful evocation of someone purely through the clothes they wear, rendered in a kind of detailed abstraction, and I felt myself drawn to it.

As someone who's worked in a number of museums, I've often drawn on collections in my writing; objects can present, in their very 'thingness', such a deal of character that I return to them, time and again, to start a poem. But it wasn't just the 'thingness' of the *subject* of Naoko's *tagasode* portrait that interested me (the cloth itself); it was the materiality of the method, combined with the way the piece suggested character through absence.

'In Praise of Hands' seems to me to be primarily a series of portraits. The characters depicted aren't absent, but they are depicted at a slant, through the details of their hands. I looked at the vivid red and blue of the hands in *Cat's Cradle A*, the gorgeous pink-purple blur of the fingers in *Flute*, the rightness of the earthy tones in *Healing Hands B*. What is shown here is character, portrayed with respect and affection.

I was interested to learn that Naoko works directly
into the woodblock, and I love her precise vocabulary
of colour. In her prints a thing isn't a certain colour
simply because it looks good (though the pleasing
harmony of the tones is undeniable and distinctive).
There is something essential about the colours she
chooses; the subjects she depicts *are* that colour.
This inspired me: Naoko is exact and confident as
well as subtle, and I wanted to do justice to these
images by capturing something of this specificity in
the poems I wrote to accompany them.

Looking at the 'Hands' prints, I noticed that the
cynic who usually squats in the back of my mind had
quietly cleared off, taken himself for a walk. He knows
when he's not welcome. Naoko's prints are full of
delight in colour and form, in rightness, and – quite
simply – they make me happy. I hope this happiness
is reflected in some way in the poems.

A mother's canopy
and a baby's tender shoots –
in both of them the fingerprint
of ancient woods.

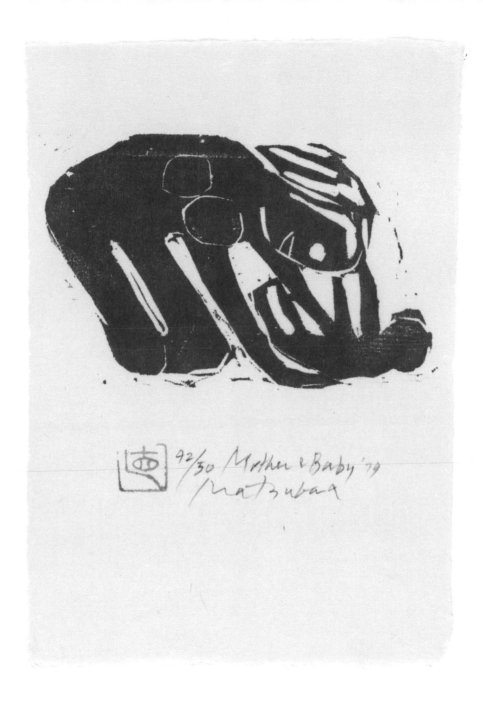

Mother & Baby
1979

Baby's hands pinch at
new words' butterfly meanings.
They await the pin.

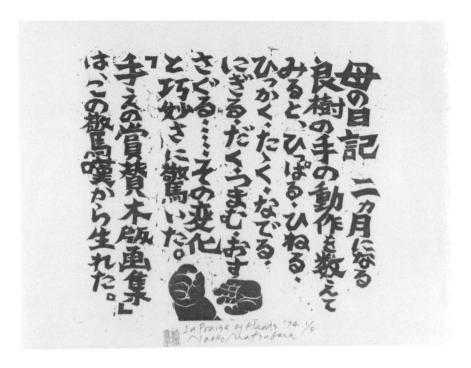

In Praise of Hands '74 1/5
Naoko Matsubara

A mother's diary – When my son Yoshiki was almost two months old, I was struck by the astonishing variety and cleverness of his hand movements – pulling, twisting, scratching, hitting, patting, squeezing, holding, pinching, pressing, exploring. My series of woodcuts 'In Praise of Hands' was born out of that sense of wonder.

In Praise of Hands
1974

Every year she raises Spring,
restarts it by remembering;
nurtures the memory, makes it new
and hands resulting buds to you.

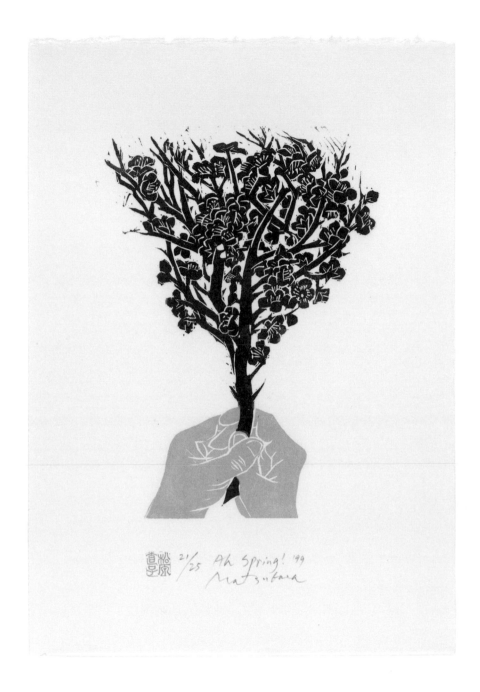

Ah Spring!
1999

Wood, cut from wood, negates the gulf
between a picture and the thing itself.

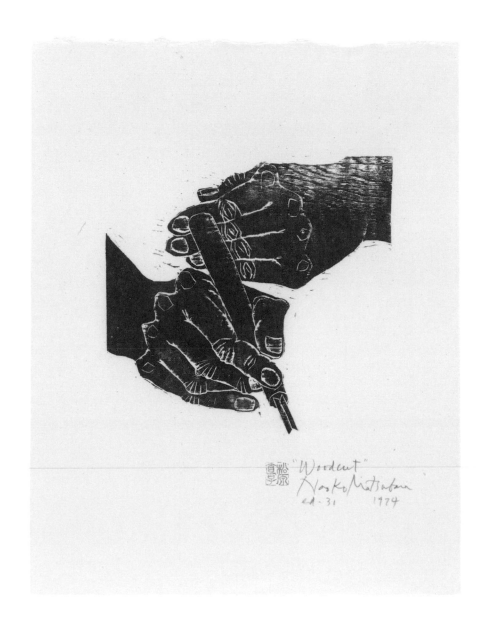

Woodcut
1974

The red hands drawing
together, almost touching,
make sense: the same way that beholding
the lemon's yellow joy is almost tasting.

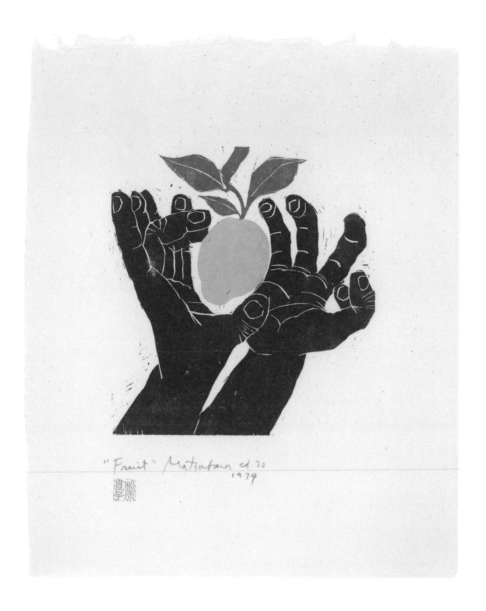

Fruit
1974

My heart's your heart,
my palm your palm;
we're tangled through and through.
For every tether of my own
a string that ties to you.

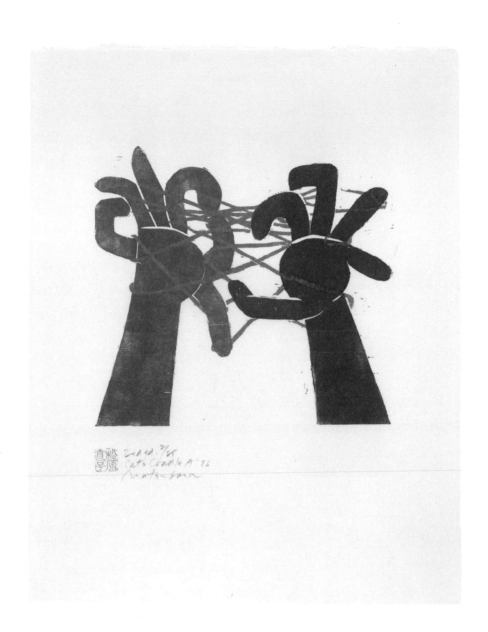

Cat's Cradle A
1976

Fuji, Rushmore, Loughrigg Fell –
we walk the tops and still can't tell
what a mountain really means.
We tie knots trying to explain
though it's well within our grasp:
The mountain is green, and does not ask.

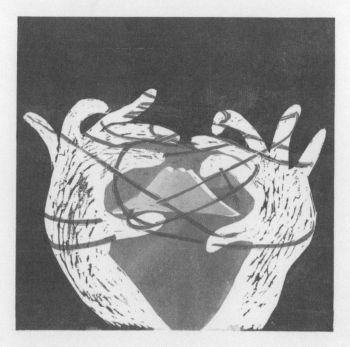

Cat's Cradle B
1994

To make from molehills mountains
is no good thing, I know – a sense
of proportion's better.
Yet the bamboo weaver makes matter
from strands of nothing-much;
and it is wonderful to watch.

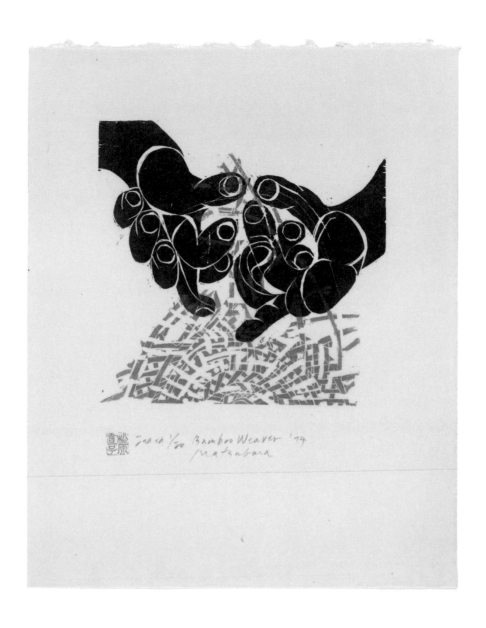

Bamboo Weaver
1974

I am

not so

fired-up

about the

pot itself, its

shape dictated

by inflexible purpose.

I warm more to the lump

of clay, the moment when

your ventriloquist hands kneading

it are the hands, briefly, of everyone.

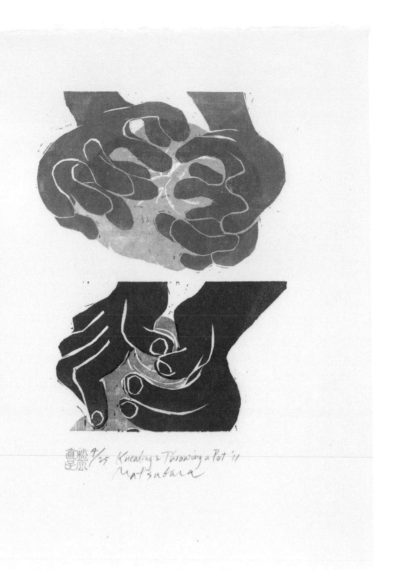

Kneading & Throwing a Pot
2011

No matter which side of the divide
you find yourself on, come closer.
There is more of me in you than I thought
and, I'll venture, vice versa.

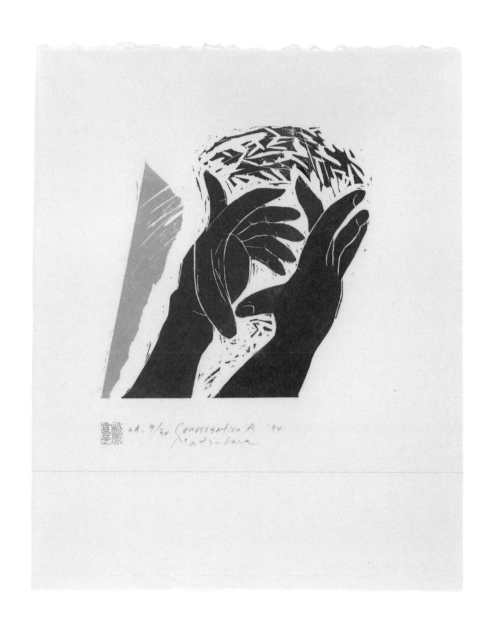

ed. 9/30 Conversation A '94
Matsubara

Conversation A
1994

For how long
have I sat locked
in indecision,
my green knuckles
caging the answer?

Deliberating
2004

I've tried to find your edges
in your fingertips and hair.
Thus outlined, you're shadowy
but still not really there.

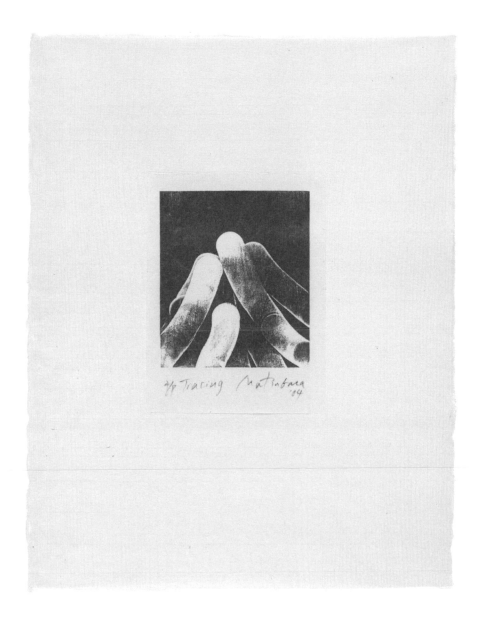

Tracing
2004

Map the outlines of your interests
and in the lassos where they overlap –
those Venn-diagram cross-hatches –
alight, and have a little think.

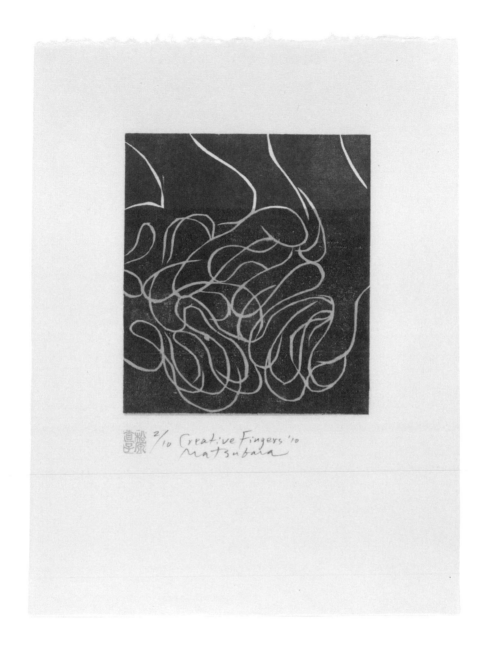

Creative Fingers
2010

With an orchestra at your disposal,

how much greater than the sum

of their parts your hands seem:

the fingers individual, distinct

as marimba mallets, and each a virtuoso.

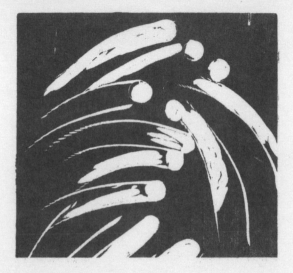

½0 Conducting '04
Matsubara

Conducting
2004

As if from a height
your quick-witted hands

descend on the melody:
a bright thread easing

through the morning haze.
The way you play

recalls the woods
in echo, or a sort of tide.

No age at all, this harmony.
Two strands – the piper and the trees –

and echoes spreading
out beyond, to everything…

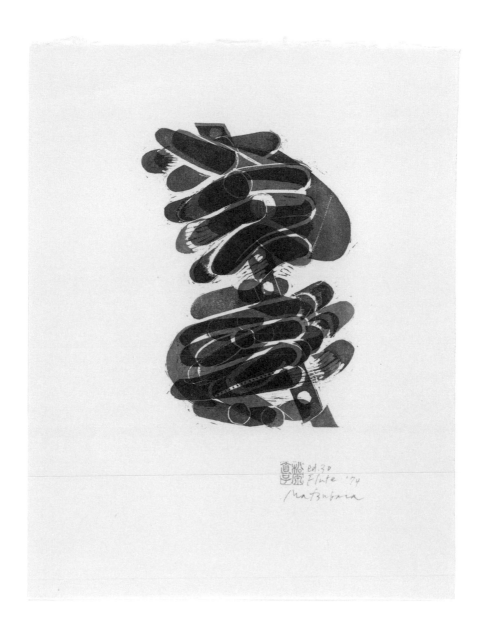

Flute
1974

As you nod to rhythm
of your own making,
the beat brings out the joyous
and deliciously ridiculous:
the branches of a stag;
an inquisitive snail; crustaceans
new to science, all agog.

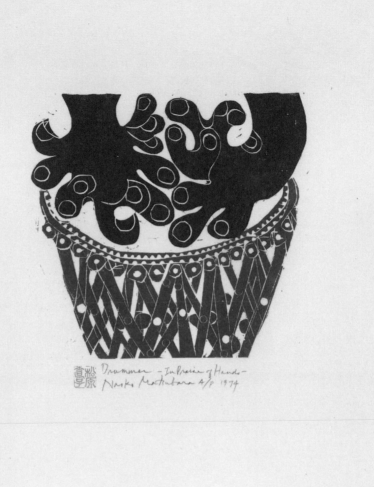

Drummer
1974

She is *precise*
like those rumoured angels
dancing on the head of a pin –
or the way the same pin extracts
a perfect bead of blood
from the exact place
where your heart-line ends.

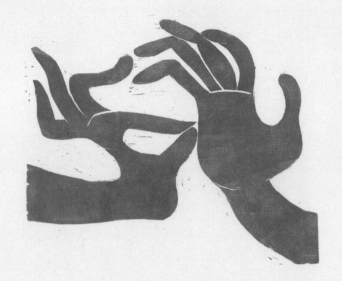

Dancer - In Praise of '74
Hands -
di Matsubara

Dancer
1974

And now bring your hands together
for everything in the world you admire.
Watch, amazed, as your fingers blur
until between them there is no distinction.

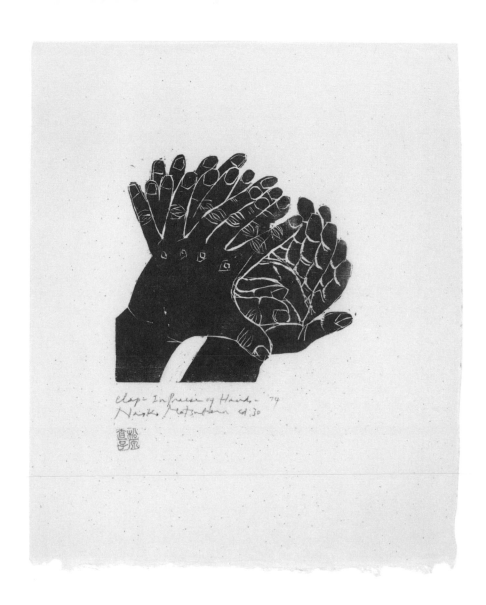

Clap
1974

We scramble to win,
forgetting the aim:
the outright fun
of the real-time game.

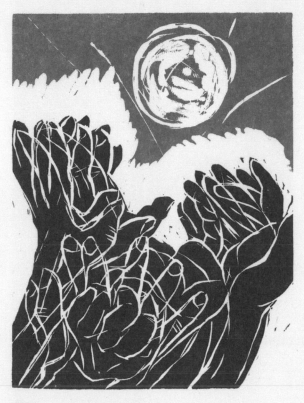

4/15 Ball Game '05
Matsubara

Ball Game
2005

Before I tell you what I want to
I'm gathering all I need to say into the air
between this fist and my open palm

so that what you'll remember is this calm moment
when nothing changes, and everything's aligned.

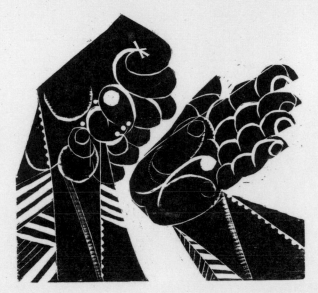

"Karate" - In Praise of Hands -
Naoko Matsubara ed. 38 1974

Karate
1974

I'm too alive to mockery
to fall for the Heart's trickery.
Since I'm not a violent sort
I shun the Club's unsubtle plot.
I know too well the Spade's work buys
just aches and pains – but can't disguise
the Diamonds winking at my sleeve.
Their chequered glare is part of me.

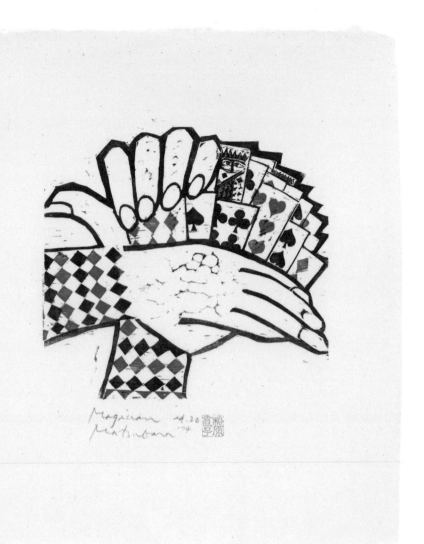

Magician
1974

As soon as the trick's
out of my hands,
your eye is on what's happening
(the dove bursting towards
the painted sky, the rabbit
nibbling on the curtains)

and not on what's happened:
I've folded myself into myself
like a neat handkerchief
ready to be put in a drawer.

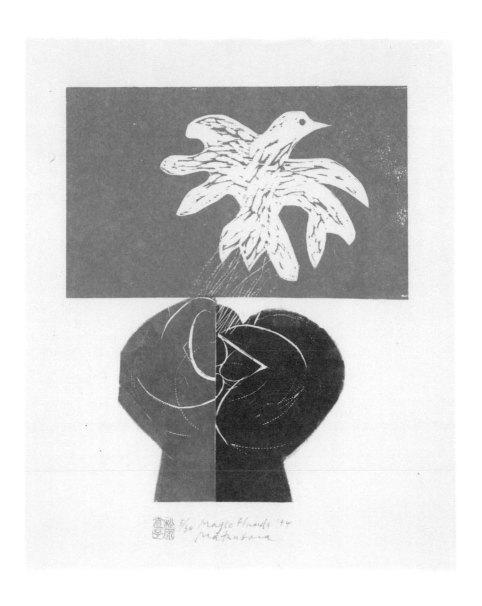

Magic Hands
1994

Explain 'entanglement', using a diagram.

Where one of us starts, the other begins.

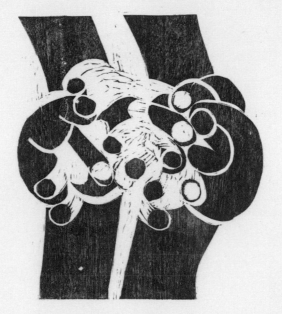

Lovers
1974

Your shadow-hands summoned
a simple dove, a stand-in silhouette
to gesture towards the truth.

Your living-hands present
the season's reality: complicated blossoms;
great gatherings of feeling.

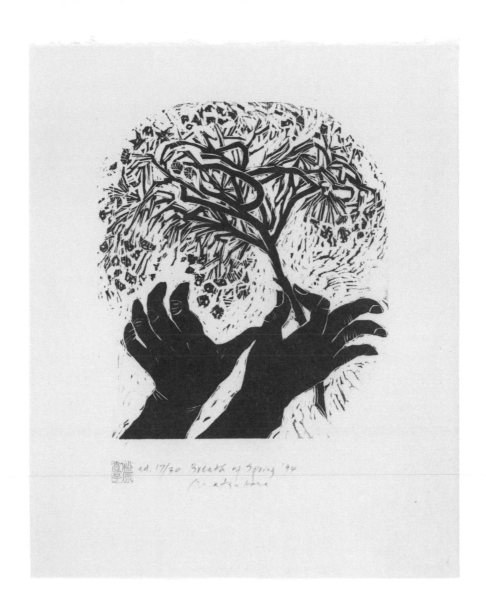

Breath of Spring
1994

I cannot stop the drops
which drip singly on skin;
but together, we pool our riches
into a clear, bright, reflecting mirror.

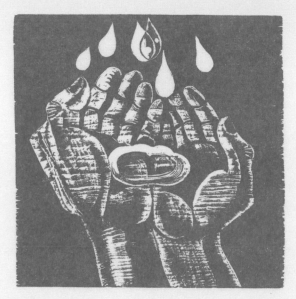

2-A ³/₂₀ Water - In Praise of Hands '74

Water
1974

If you learn one thing,
learn this, she said –
how time and again
patience is rewarded.

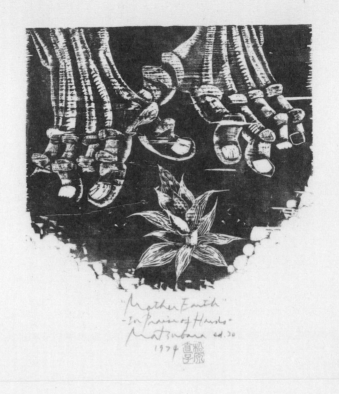

Mother Earth
1974

It isn't clear at what distance
the close-to fingers you knew
like the proverbial *back of your hand*
morphed into this mountainside running
with faraway rivers, viewed from on high.

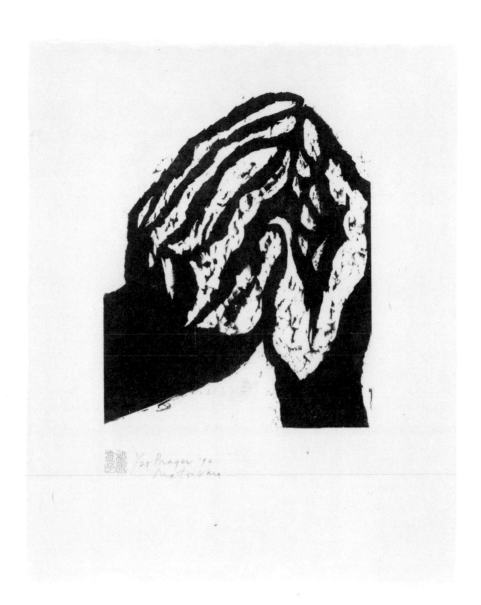

Prayer
1994

This is how to reach for acceptance:
between forefinger and thumb, lightly.

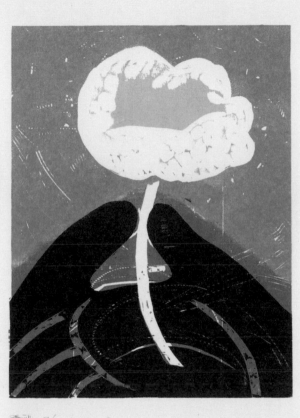

Buddha's Hand
1994

Even before the touch
you feel the hand's power
jolt straight to the heart of the matter,
like a bolt of electricity through water.

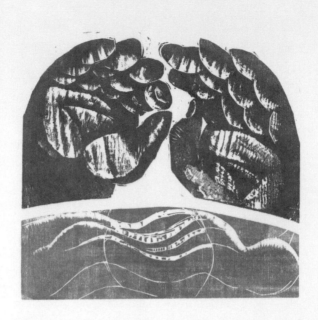

Healing Hands
1996

The nurse who handled
your broken heart
not only made you better:
he came away with strong fibres
woven in him that could only
have come from you.

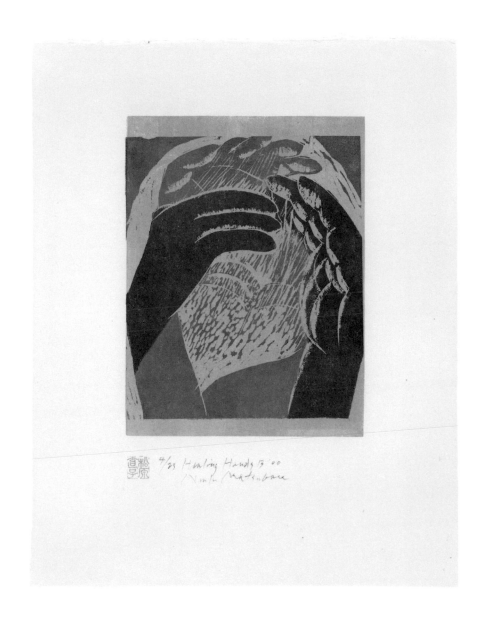

Healing Hands B
2000

My mother handed me a gift.
'Close eyes.' I took it in my ready palms.
It was lighter than I would have thought.
In slipping it from hand to hand
we'd traded more than its small weight.
Some ancient magic touched us
as it tipped from *hers* to *mine;* we
changed position, expectation, tense.

I'm here, and looking at it still.
This little thing her clever hands
made happen is more precious
for the growing space between us –
more vital with each passing
hour. I watch it closely now.

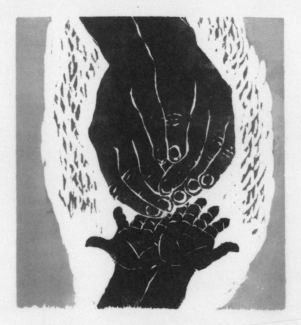

The Present
2020

The Artist

For decades, the distinguished print artist Naoko Matsubara has been creating joyful and innovative woodcuts that constantly push the boundaries of the woodblock medium. The artist, whose work is in major public and private collections around the world, seeks to capture the essence of a subject in its simplest form, working both in monochrome and with multiple blocks and colours. Inspired by nature, place, literature, music and movement, her prints range from intimate to monumental, playful to contemplative, figurative to abstract. Yet all her work is characterised by a strong sense of spontaneity and a bold freedom of expression. In 2018 she generously donated over 100 of her works to the Ashmolean Museum, including the series 'In Praise of Hands'. We are delighted to commemorate the gift with this new collaborative work.

The daughter of an eminent Shinto priest in Kyoto, Naoko Matsubara was introduced to printmaking in 1957 while studying design and Japanese painting at Kyoto City University of Arts. One of her teachers, the Austrian artist Felice Rix, encouraged students to carve straight into the woodblock rather than making a preliminary sketch or drawing onto the block first. This technique encouraged the creation of dynamic and spontaneous work and Matsubara has used this method throughout her career.

In 1961 a Fulbright Scholarship took her to the
Carnegie Institute in Pittsburg, U.S.A. and it was here
that she fully embraced the woodcut as her preferred
artistic medium. After several years working with the
German-American wood engraver Fritz Eichenberg
in New York, Naoko settled in Oakville, Canada in
1972. Her work is immersed in the modern artistic
traditions of Europe and America, while she also
maintains a strong connection with her Japanese
cultural roots. Yet the art she creates expresses a very
personal vision. Her early works depicted the people
and places she encountered in the United States
and Europe, as well as in her hometown of Kyoto.
The prints were at first mainly monochrome,
generally black and white, but she soon began to
experiment with colour, adding extra tones or
harmonising colours and playing with negative and
positive space. Her work is constantly evolving in
fresh and surprising directions, whether branching
into the abstract, experimenting with collage,
or using carved and coloured woodblocks arranged
in harmonious, dynamic grids to create murals
in which the medium itself becomes the artwork.

Naoko Matsubara's prints often form a suite, related
by themes or an accompanying narrative. 'In Praise

of Hands', initially inspired by her baby's exploring hands, soon expanded into a wider visual exploration of the human hand. Engaged in sport, dance, music, prayer or an assortment of creative acts, the bold, disembodied hands are depicted in a range of styles, abstract but representational. Some are angular, some fluid, others knotty or impressionistic. Whether capturing a sense of movement or stillness, exploring the symbolism of hand gestures, playing with form and colour, or expressing a mood or emotion – energetic, earthy, serious, humorous, disciplined or spiritual – Naoko's hands all convey a sense of appreciation and wonder.

The diversity of mood and expression within 'In Praise of Hands' is taken up and explored further in the accompanying poems by Penny Boxall. The idea of a dialogue between image and text runs through Naoko Matsubara's work, from her early illustrations of classic Japanese and Chinese folk tales in the 1960s. Her first portfolio of prints, *Solitude*, created in 1971, was a response to Henry David Thoreau's book *Walden*, while in 1999 she created the portfolio *Tokonoma* in collaboration with the English poet James Kirkup. Each print in the *Tokonoma* set combines poem and image: for some Naoko created images and James Kirkup responded with his poems; for others the poem

provided inspiration for the design. In the 1980s Robin Skelton, a British poet based in Victoria, British Columbia, began working on a series of beautiful poems for 'In Praise of Hands', but the project was never completed. So we were delighted to set in motion a new collaboration between Naoko Matsubara and the talented young poet Penny Boxall, who created a new set of poems to accompany the series.

The very last print in the series was added in May 2020, when Naoko invited Penny to write another poem for which a brand-new woodcut would be created. This was at the height of the dreadful coronavirus pandemic; yet, wonderfully, out of the emotional uneasiness of lockdown and despite practical obstacles such as the impossibility of accessing suitable woodblocks, 'The Present' emerged – a creative exchange in words and colours whose imagery of connection between mother and child provides a moving coda to a series first inspired by a mother's wonder at her baby.

We are delighted that this elegant book has been designed by Yoshiki Waterhouse, Naoko Matsubara's son – whose baby hands were the original inspiration for the series.

The Poet

The poems that appear alongside the woodcuts were
specially written for this book by Penny Boxall. In their
clarity and playfulness, in their deceptive simplicity,
they share some of the joyful, evocative qualities of
Naoko Matsubara's woodcuts.

We knew Penny from her time working in the Ashmolean
Museum's Eastern Art Department. Penny has worked
for a number of museums, including literary museums
like the Wordsworth Trust and the Laurence Sterne
Trust at Shandy Hall, and with decorative and fine art
collections at the Royal Collection as well as the
Ashmolean. She draws on these museums in her writing,
which often wonders how to extrapolate or imagine past
lives through the medium of an object.

After she graduated from the Creative Writing MA at the
University of East Anglia, her debut poetry collection,
Ship of the Line, won the 2016 Edwin Morgan Poetry
Award and was praised by the Scottish poet Jackie Kay as
'…beautifully crafted. Reading her is to go on an
interesting journey of exploration – stopping at
fascinating places along the way. She has a curator's
mind and is always putting one thing beside another
in an unexpected way.' Her second collection,
Who Goes There? was published in 2018 and she is
currently working on her third collection.

She has also written a historical novel for children, which was shortlisted for the 2020 Hachette Children's Novel Award.

Penny has won a number of prizes, including the 2018 Mslexia/PBS Poetry Competition and awards from New Writing North and the Author's Foundation. Her poems have appeared in various publications, including *The Sunday Times*, *The Dark Horse*, *The North*, *The Rialto*, *The Scotsman*, *Magma*, and *Mslexia*.

She has held writing residencies and fellowships at Gladstone's Library in North Wales, Hawthornden Castle, and Chateau de Lavignyand has taught poetry on the MA course at Oxford Brookes University and at the UK's Poetry School. She was Visiting Research Fellow in the Creative Arts at Merton College, Oxford in autumn 2019, and is the 2020-21 Royal Literary Fund Fellow at the University of York.

Clare Pollard, Curator of Japanese Art
Ashmolean Museum

In Praise of Hands

British Library Cataloguing in Publications Data

A catalogue record for this book is available
from the British Library.
ISBN: 978-1-910807-44-6
All rights reserved. No part of this publication may be
transmitted in any form or by any means, electronic
or mechanical, including photocopy, recording or any
storage and retrieval system, without the prior
permission in writing of the publisher.

Catalogue designed by Yoshiki Waterhouse

Printed and bound by Gomer Press, UK

For further details of Ashmolean titles please visit:
www.ashmolean.org/shop